This new edition of *Heartland* is dedicated to the memory of Dr. Jerry J. Mallett, founder of the Mazza Museum of International Art from Picture Books. His contribution to the world of children's books is legendary.

W.M.

Published in 2015 by
David R. Godine Publisher
Post Office Box 450
Jaffrey, New Hampshire 03452
www.godine.com

LIBRARY OF CONGRESS CATALOGING-IN-PUBLICATION DATA

Siebert, Diane.
Heartland / written by Diane Siebert ; illustrated by Wendell Minor.
pages cm
ISBN 978-1-56792-535-7 (hardcover : alk. paper)
ISBN 978-1-56792-536-4 (softcover : alk. paper)
1. Children's poetry, American. 2. Middle West—Juvenile poetry. I. Minor, Wendell. II. Title.

PS3569.I36H4 2015
811'.54--DC23

2015024990

First Edition
Printed in China

HEARTLAND

BY DIANE SIEBERT · PAINTINGS BY WENDELL MINOR

DAVID R. GODINE, *Publisher*

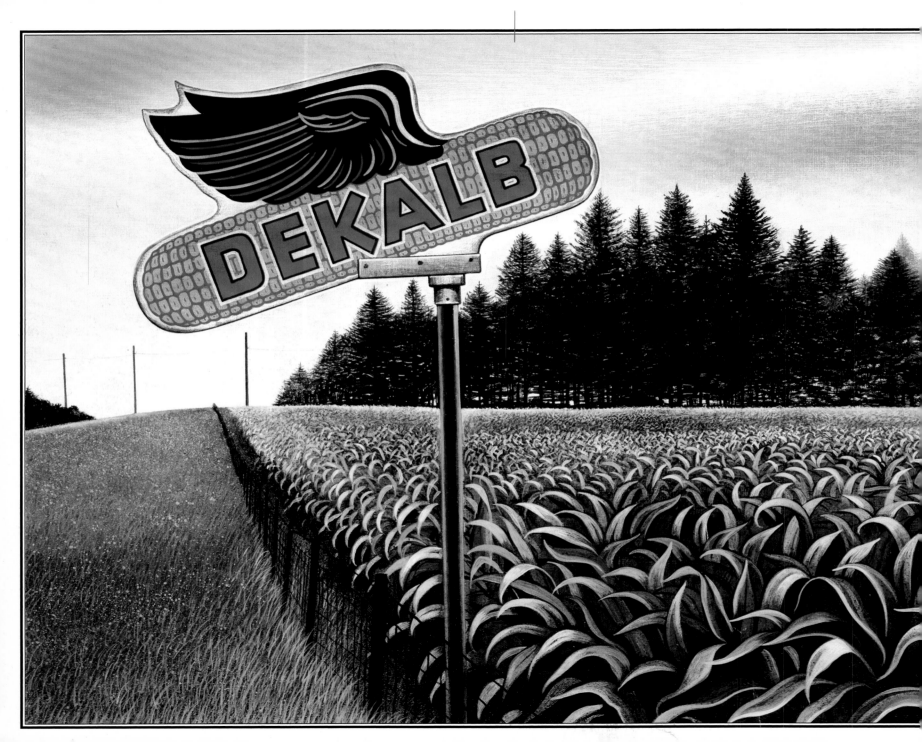

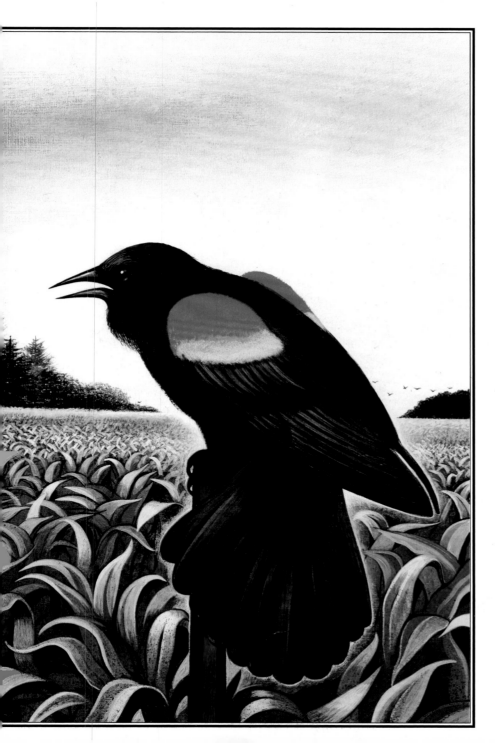

I am the Heartland.
Great and wide.
I sing of hope.
I sing of pride.

I am the land where wheat fields grow
In golden waves that ebb and flow;
Where cornfields stretched across the plains
Lie green between the country lanes.

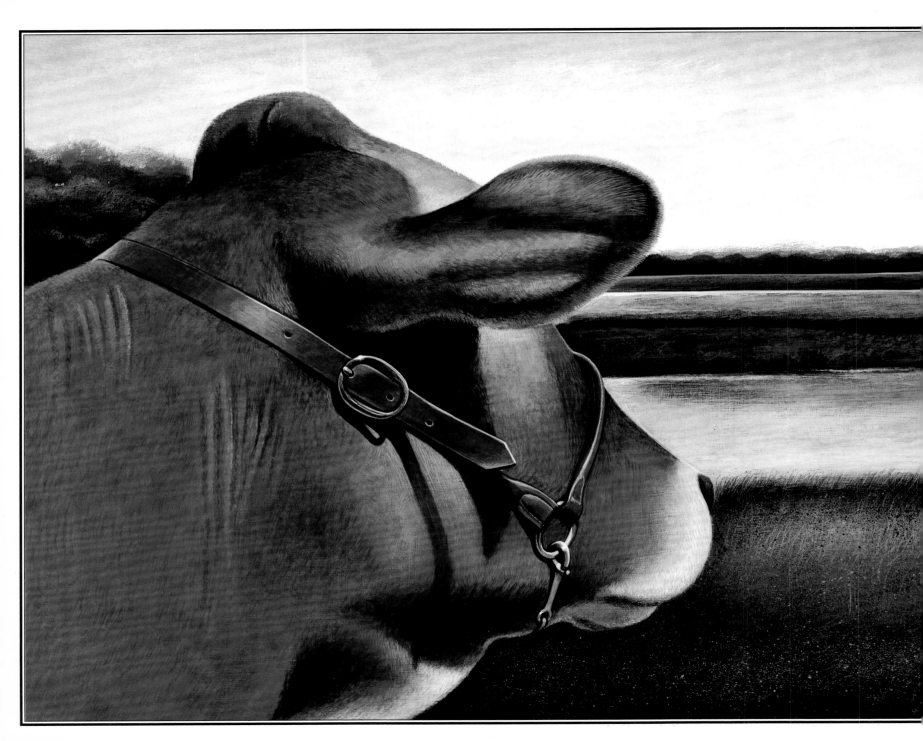

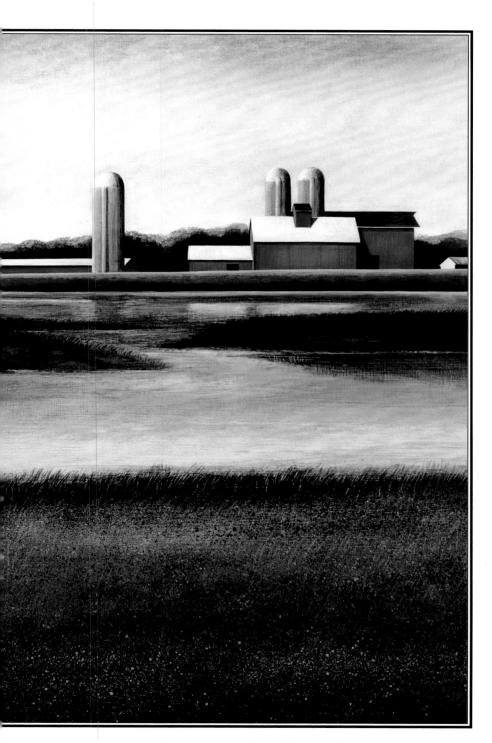

I am the Heartland.
Shaped and lined
By rivers, great and small, that wind
Past farms, whose barns and silos stand
Like treasures in my fertile hand.

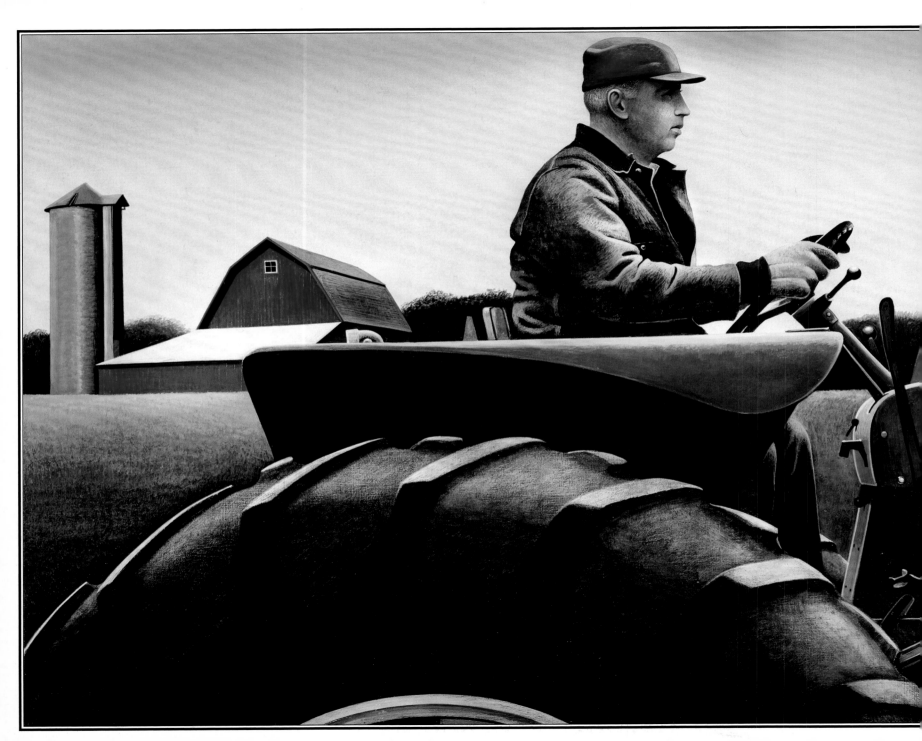

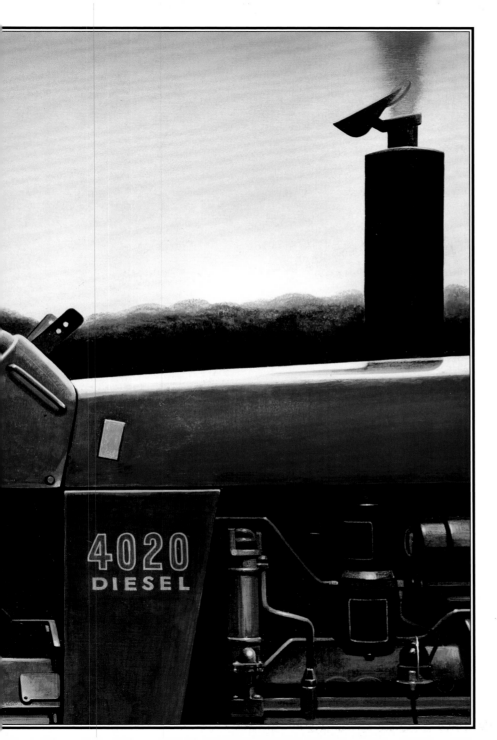

I am the Heartland.
I can feel
Machines of iron, tools of steel,
Creating farmlands, square by square—
A quilt of life I proudly wear:

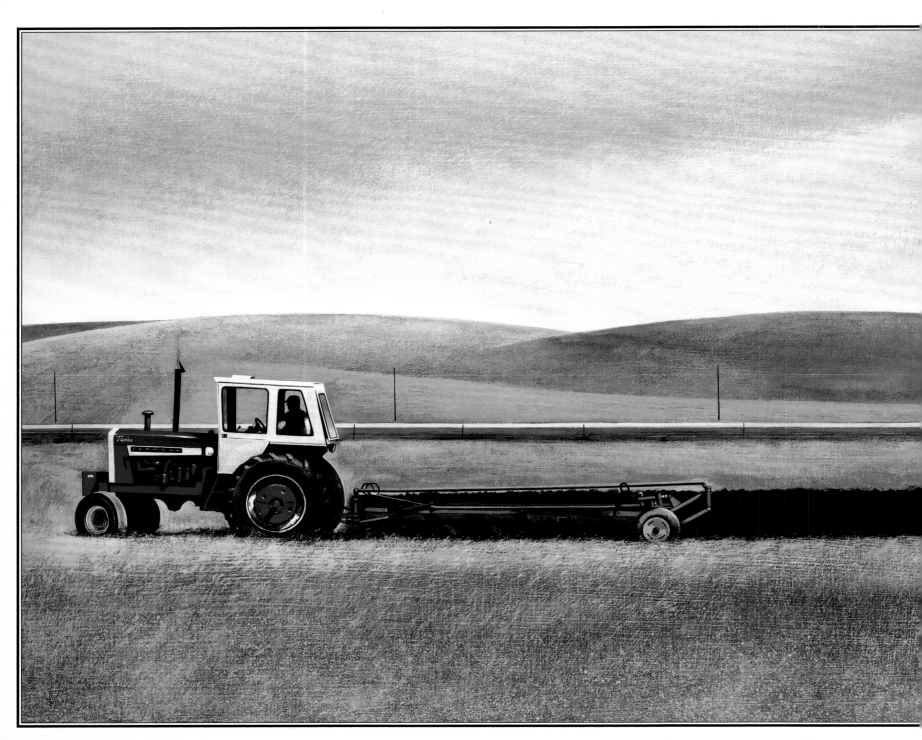

A patchwork quilt laid gently down
In hues of yellow, green, and brown
As tractors, plows, and planters go
Across my fields and, row by row,
Prepare the earth and plant the seeds
That grow to meet a nation's needs.

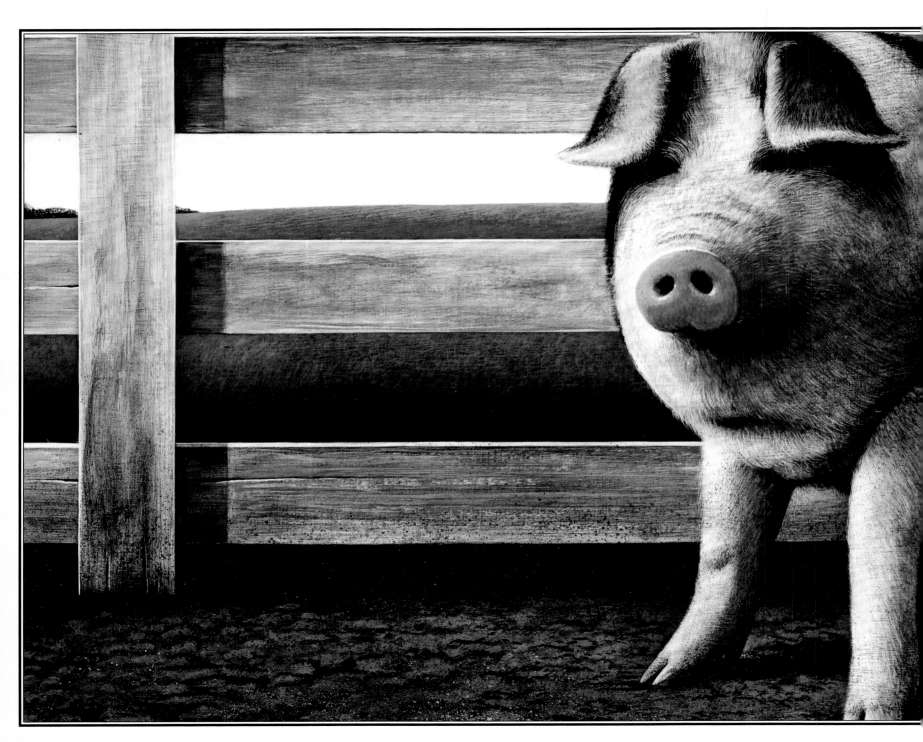

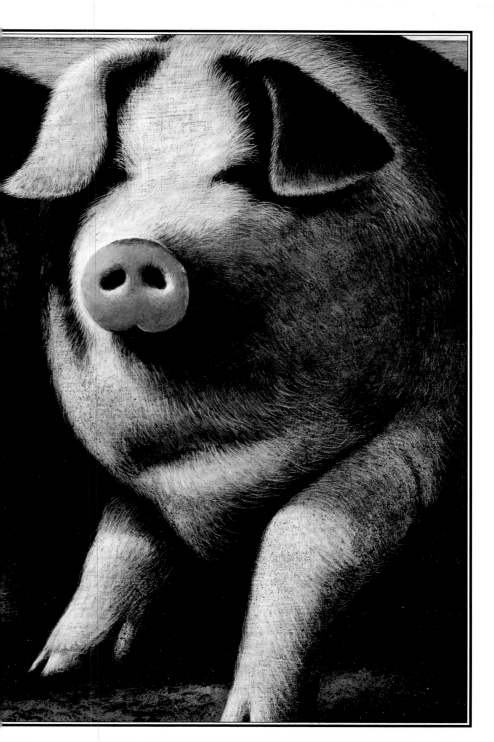

A patchwork quilt whose seams are etched
By miles of wood and wire stretched
Around the barns and pastures where
The smell of livestock fills the air.
These are the farms where hogs are bred,
The farms where chicks are hatched and fed;
The farms where dairy cows are raised,
The farms where cattle herds are grazed;
The farms with horses, farms with sheep—
Upon myself, all these I keep.

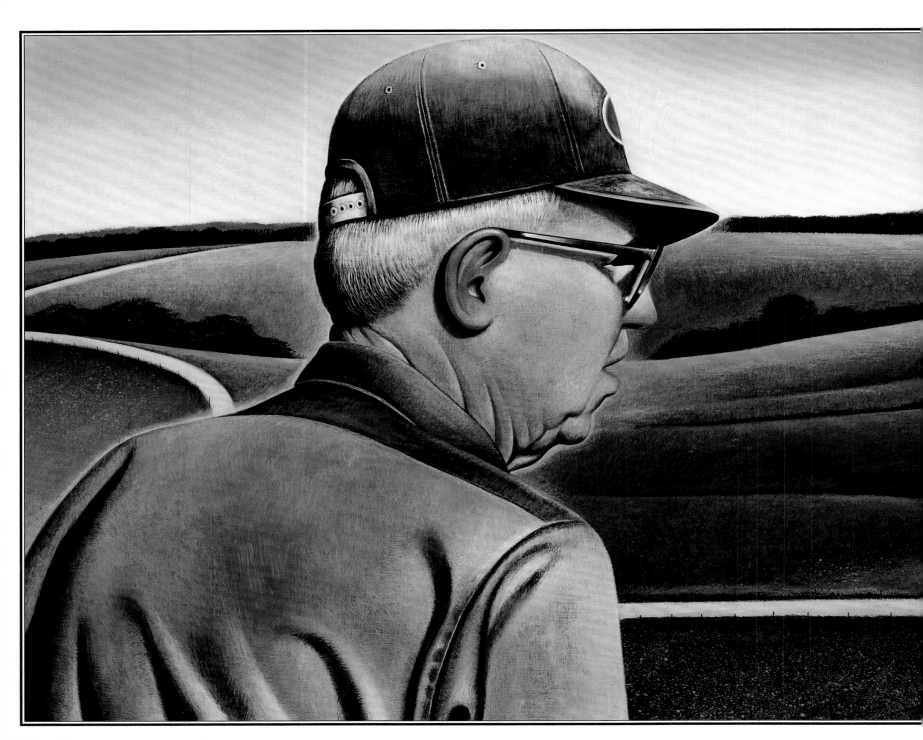

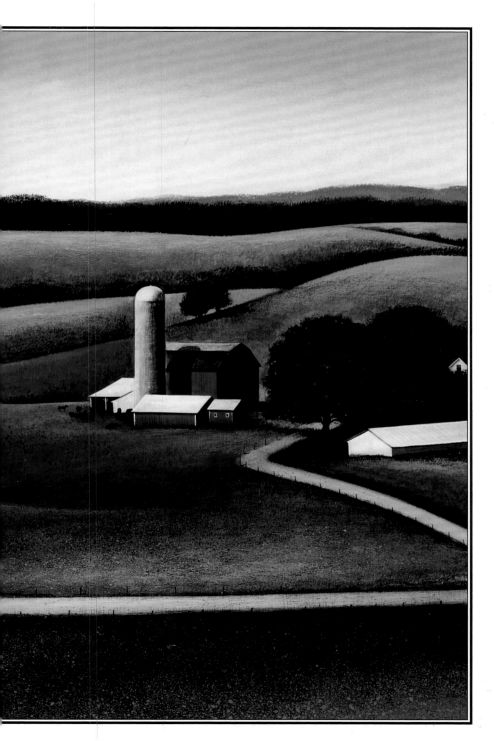

I am the Heartland.
On this soil
Live those who through the seasons toil:

The farmer, with his spirit strong;
The farmer, working hard and long,
A feed-and-seed-store cap in place,
Pulled down to shield a weathered face—
A face whose every crease and line
Can tell a tale, and help define
A lifetime spent beneath the sun,
A life of work that's never done.

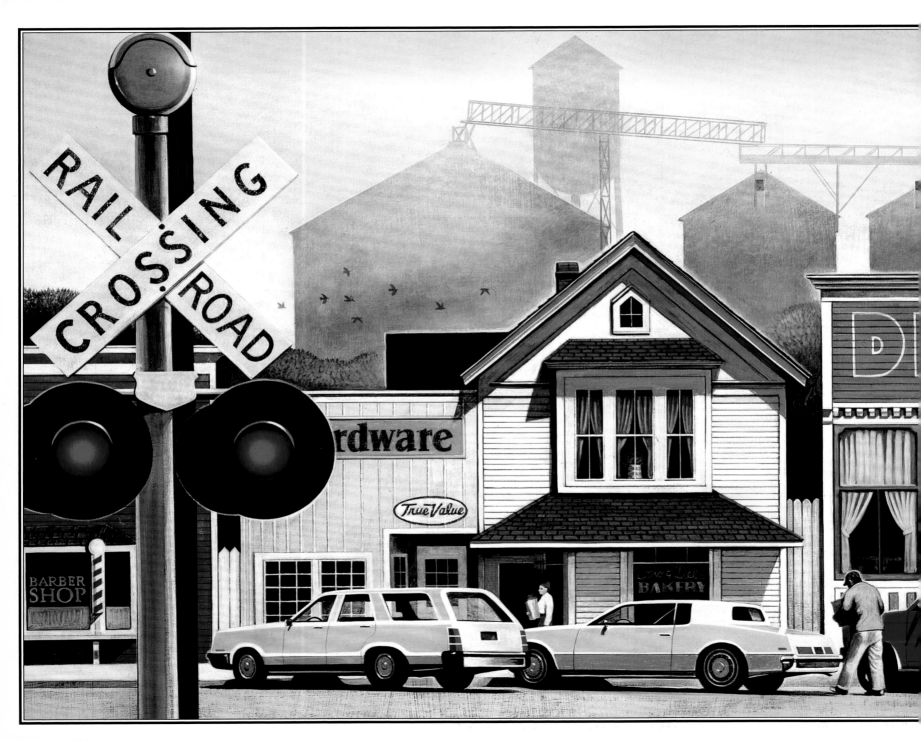

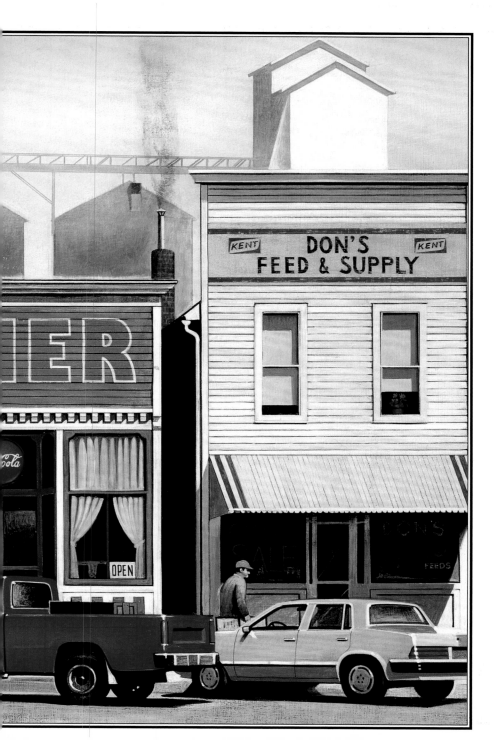

I am the Heartland.
On these plains
Rise elevators filled with grains.
They mark the towns where people walk
To see their neighbors, just to talk;
Where farmers go to get supplies
And sit a spell to analyze
The going price of corn and beans,
The rising cost of new machines;
Where steps are meant for shelling peas,
And kids build houses in the trees.

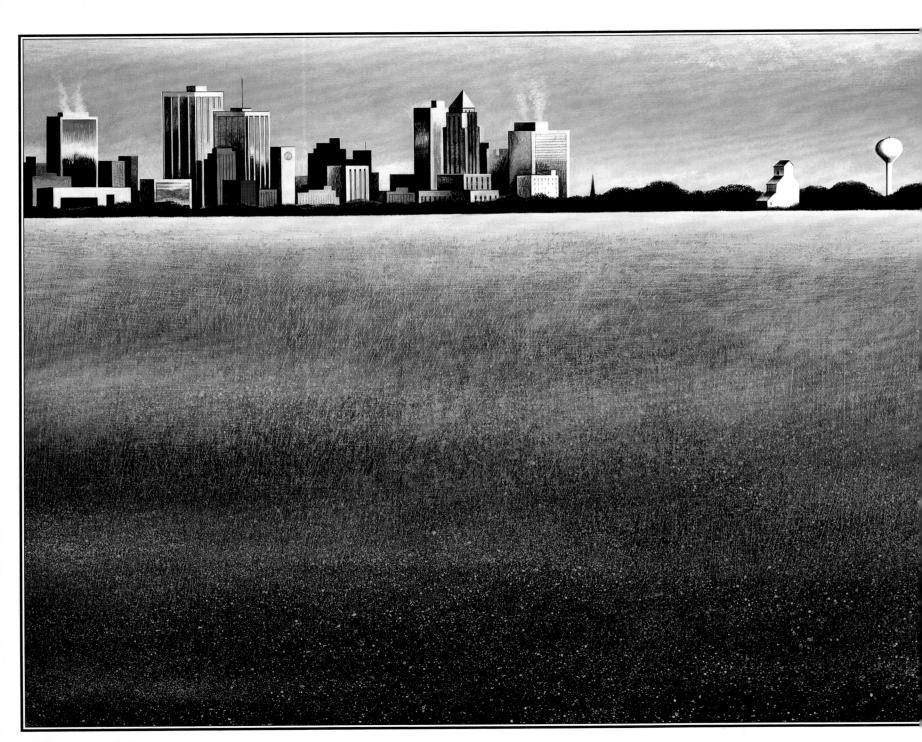

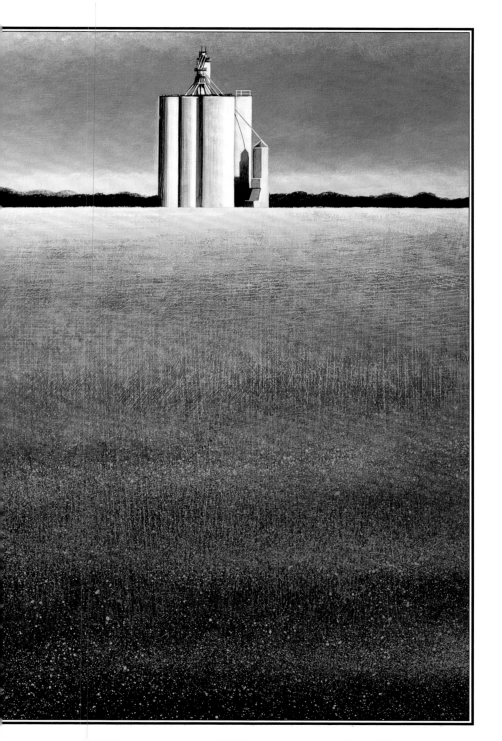

I am the Heartland:
In my song
Are cities beating, steady, strong,
With footsteps from a million feet
And sounds of traffic in the street;
Where giant mills and stockyards sprawl,
And neon-lighted shadows fall
From windowed walls of brick that rise
Toward the clouds, to scrape the skies;
Where highways meet and rails converge;
Where farm and city rhythms merge
To form a vital bond between
The concrete and the fields of green.

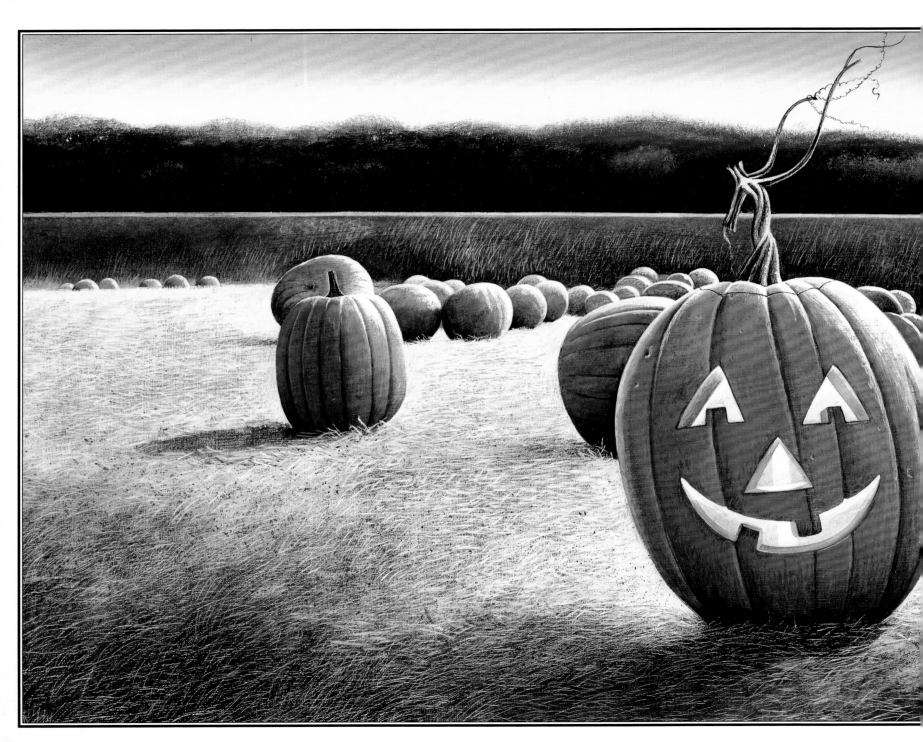

I am the Heartland:
Earth and sky
And changing seasons passing by.

I feel the touch of autumn's chill,
And as its colors brightly spill
Across the land, the growing ends,

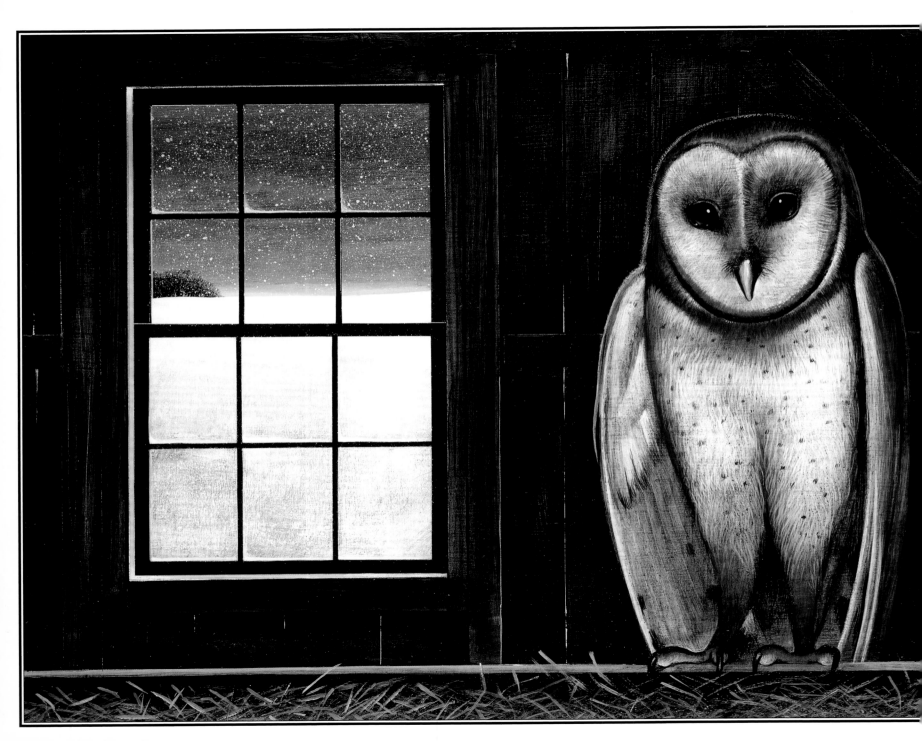

And winter, white and cold, descends
With blizzards howling as they sweep
Across me, piling snowdrifts deep.
Then days grow longer, skies turn clear,
And all the gifts of spring appear—
The young are born, the seedlings sprout;

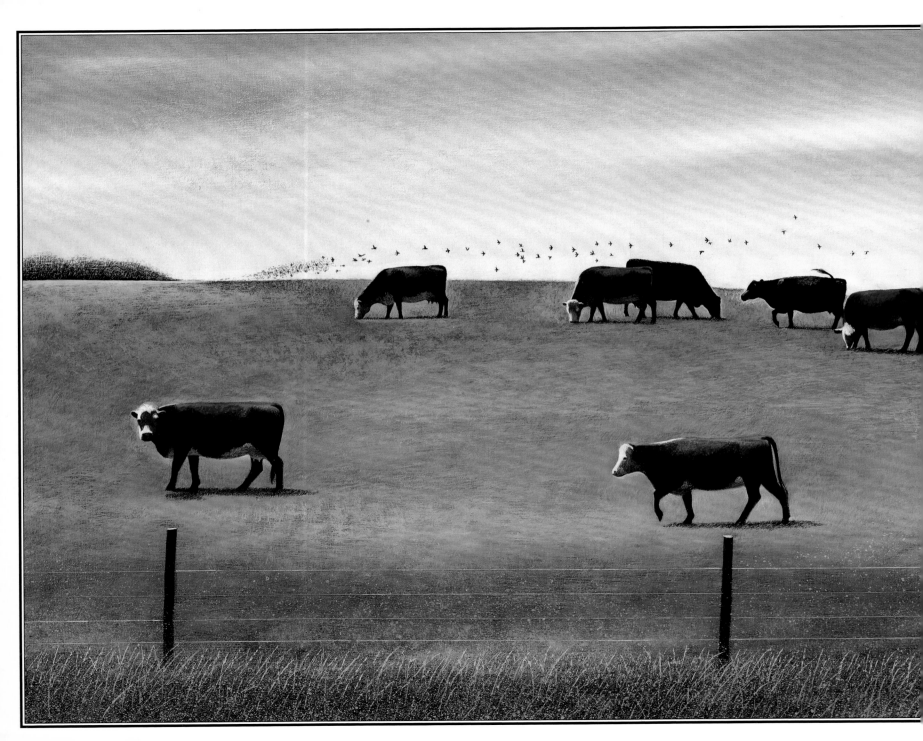

Before me, summer stretches out
With pastures draped in lush, green grass,
And as the days of growing pass,
I feel the joy when fields of grain
Are blessed by sunlight, warmth, and rain;

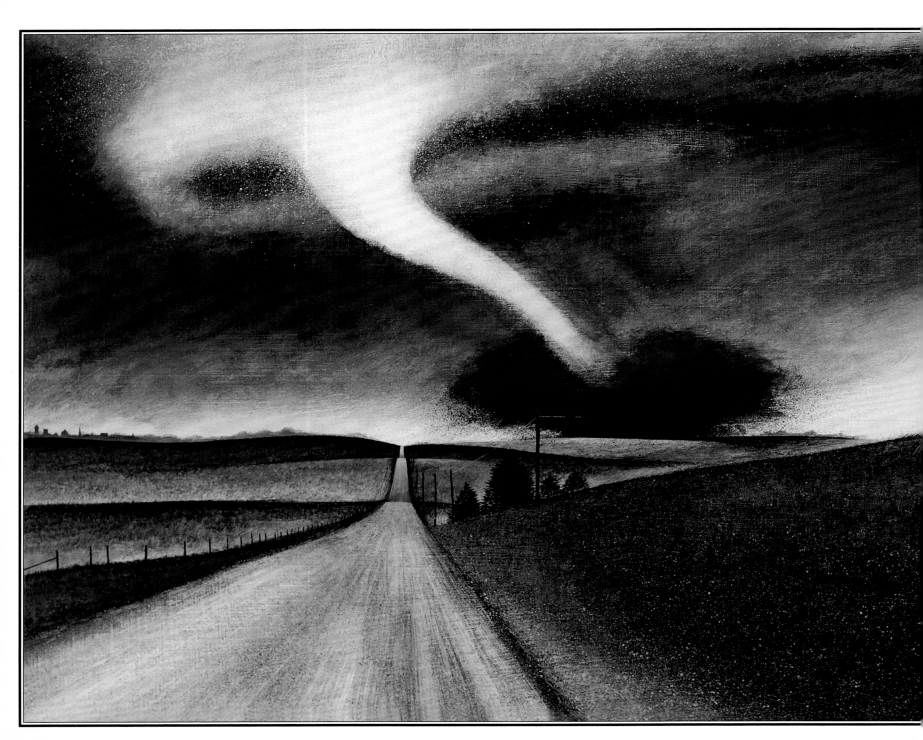

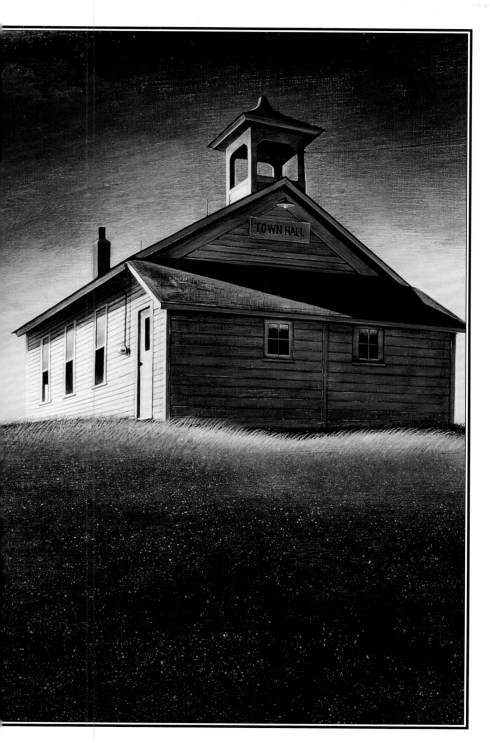

For I have learned of drought and hail,
Of floods and frosts and crops that fail,
And of tornadoes as they move
In frightening paths, again to prove
That in the Heartland, on these plains,
Despite Man's power, Nature reigns.

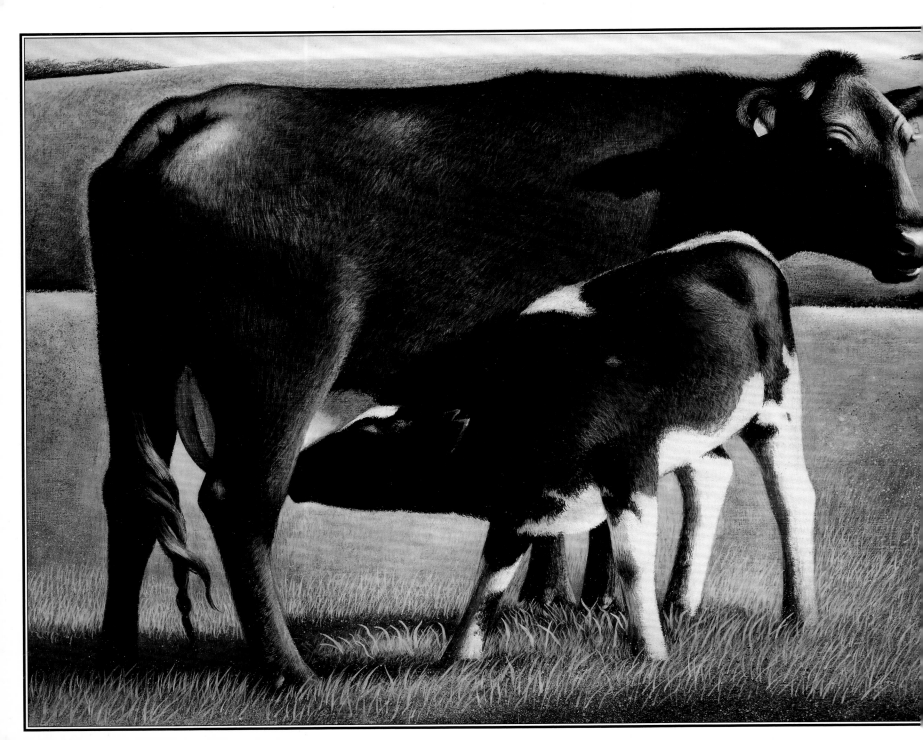

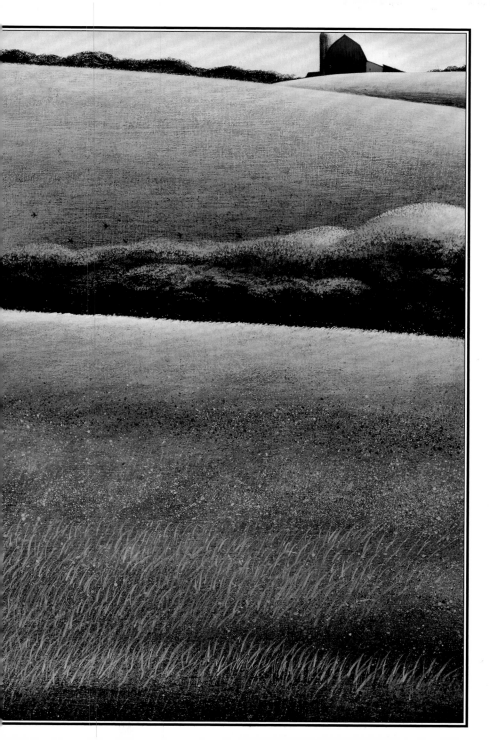

I am the Heartland.
Smell the fields,
The rich, dark earth, and all it yields;
The air before a coming storm,
A newborn calf, so damp and warm;
The dusty grain in barns that hold
The bales of hay, all green and gold.

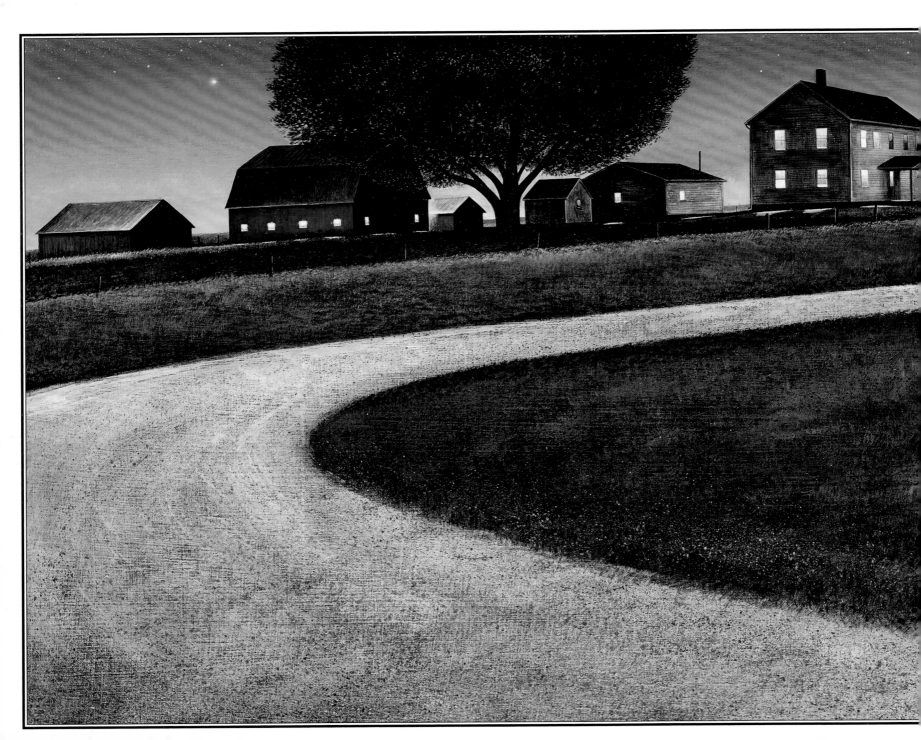

I am the Heartland.
Hear me speak
In voices raised by those who seek
To live their lives upon the land,
To know and love and understand
The secrets of a living earth—
Its strengths, its weaknesses, its worth;
Who, Heartland born and Heartland bred,
Possess the will to move ahead.

I am the Heartland.
I survive
To keep America, my home, alive.